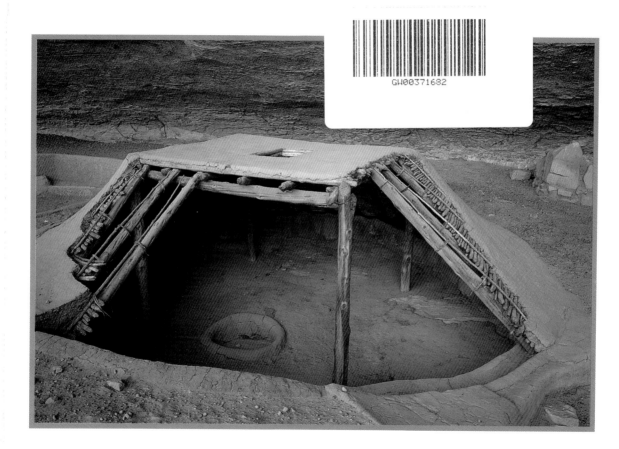

Step House Pithouses, Mesa Verde National Park. The reconstructed pithouses found in Step House on Wetherill Mesa were the architectural precursors to both the pueblo and kiva structures. Step House was occupied for about 700 years before the alcove was used for a classic style cliff dwelling.

From the MESA VERDE WISH YOU WERE HERE PRINT BOOK

SIERRA PRESS: Visit us at www.nationalparksusa.com

PHOTO © LAURENCE PARENT

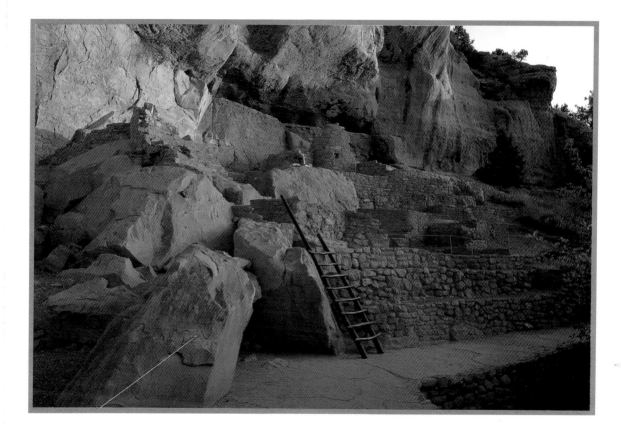

Step House, Mesa Verde National Park. Named for an ancient staircase leading up to the mesa top, Step House offers a unique view of several classic Mesa Verde features. Pithouses excavated next to the cliff dwelling illustrate multiple periods of occupation, believed to be common in the alcoves throughout the area. This view also illustrates the Ancestral Puebloan method of terracing used to overcome uneven alcove floors.

From the MESA VERDE WISH YOU WERE HERE® PRINT BOOK

SIERRA PRESS: Visit us at www.nationalparksusa.com

PHOTO © JIM WILSON

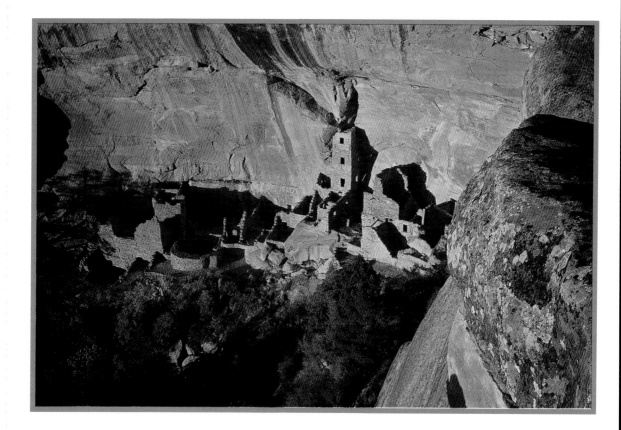

Square Tower House, Mesa Verde National Park. The four story structure, for which Square Tower House was named, is not technically a tower. It was surrounded by a complex of buildings, many of which were several stories in height. The square, straight walls are an example of the fine quality of masonry built by the Ancestral Puebloan people.

From the MESA VERDE WISH YOU WERE HERE® PRINT BOOK

SIERRA PRESS: Visit us at www.nationalparksusa.com

PHOTO © TOM TILL

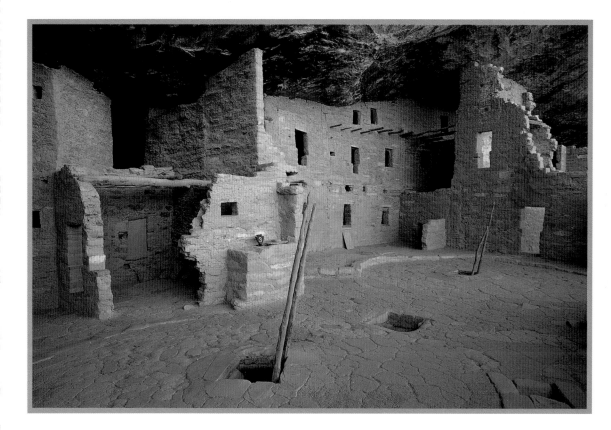

Spruce Tree House, Mesa Verde National Park. The use of kiva roofs as plazas or courtyards demonstrates the efficient use of space by the Ancestral Puebloans. The uses of these courtyards are not certain but were probably work areas and gathering places. The T-shaped doorways looking out onto the courtyard are one of Mesa Verde's characteristic architectural features.

From the MESA VERDE WISH YOU WERE HERE® PRINT BOOK

SIERRA PRESS: Visit us at www.nationalparksusa.com

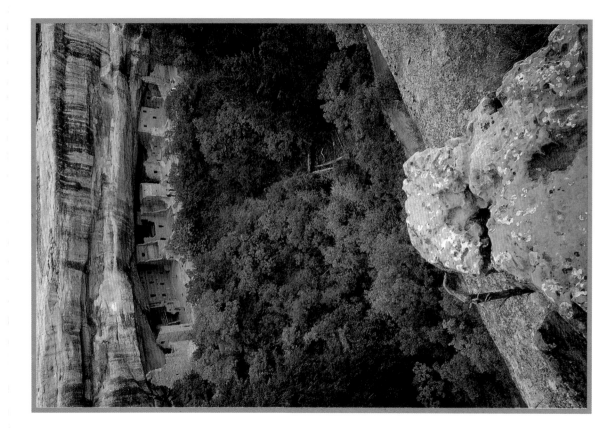

Spruce Tree House, Mesa Verde National Park. Spruce Tree House, one of the largest cliff dwellings in Mesa Verde, is also the best preserved. Nearly 80% of the standing walls are original although some have been stabilized. This alcove was probably a very attractive home site because of its accessibility, the southwestern orientation, and a nearby reliable water supply.

From the MESA VERDE WISH YOU WERE HERE® PRINT BOOK

PHOTO © TOM TILL

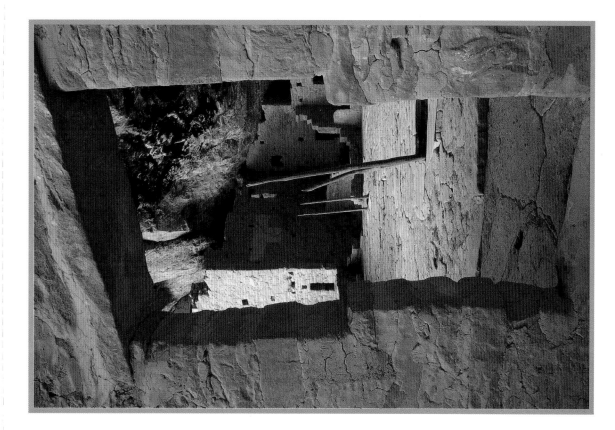

Spruce Tree House, Mesa Verde National Park. T-shaped doorways are one of Mesa Verde's characteristic architectural features. Because they often face kivas, which are believed to be ceremonial, the T-shaped doorway is also thought to have spiritual meaning. However, these doorways have practical value as their shape allows easy access to rooms. Whether used for practical reasons, or for their aesthetic value, the T-shaped doorways give us a special view into the Ancestral Puebloan world.

From the MESA VERDE WISH YOU WERE HERE® PRINT BOOK

SIERRA PRESS: Visit us at www.nationalparksusa.com

PHOTO © LARRY LINDAHL

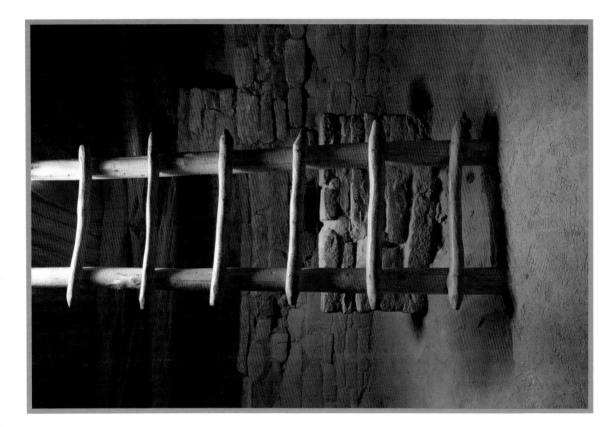

Kiva, Spruce Tree House, Mesa Verde National Park. Circular underground rooms, called kivas, are commonly found in the cliff dwellings of Mesa Verde National Park. Archeologists believe one of their uses may have been ceremonial, based on their continued use by Puebloan people today.

From the MESA VERDE WISH YOU WERE HERE ® PRINT BOOK

SIERRA PRESS: Visit us at www.nationalparksusa.com

PHOTO © LEWIS KEMPER

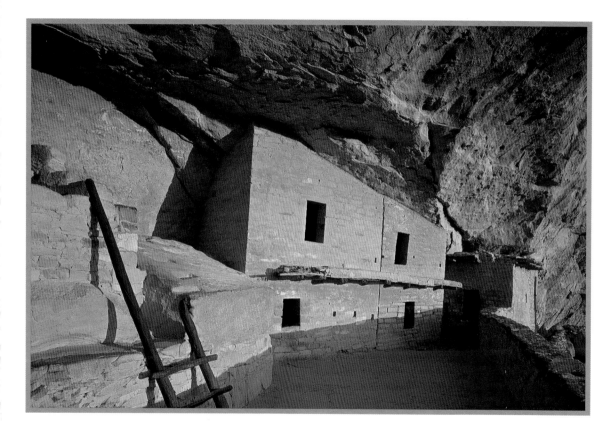

Balcony House, Mesa Verde National Park. The balcony for which Balcony House was named is seen in this view. The balcony was constructed using the structural beams of the room below for support. Sticks and planks were laid across the beams and finished with mud. The balcony probably provided access to the upper stories in the village.

FIRST
CLASS
POSTAGE
REQUIRED

From the MESA VERDE WISH YOU WERE HERE™ PRINT BOOK

SIERRA PRESS: Visit us at www.nationalparksusa.com

PHOTO © LAURENCE PARENT

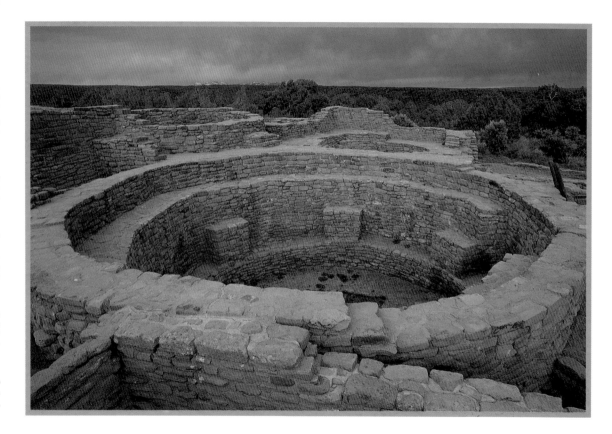

Far View, Mesa Verde National Park. Kivas were an integral part of the Ancestral Puebloan villages at Mesa Verde as seen here at Far View. Six stone pilasters supported a pole, brush, and plaster roof structure which formed the courtyard floor. Far View has five kivas and approximately 40 ground floor rooms. It was built between A.D. 1100 and 1300 and probably contained 50 rooms in its original two-story design.

From the MESA VERDE WISH YOU WERE HERE PRINT BOOK

SIERRA PRESS: Visit us at www.nationalparksusa.com

PHOTO © JEFF NICHOLAS

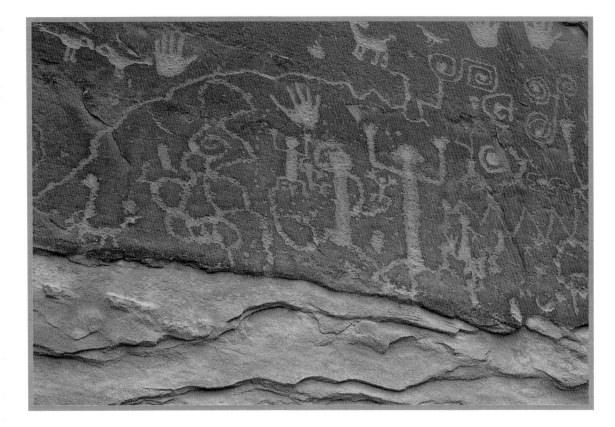

Petroglyph Panel, Petroglyph Point Trail, Mesa Verde National Park. One of the largest intact petroglyph panels in Mesa Verde National Park, this work represents a form of written communication used by the Ancestral Puebloan people. Petroglyphs are pecked into stone walls or boulders and some archeologists believe they indicate a fairly successful community as these messages must have been time consuming to create. This panel can be viewed on the Petroglyph Point Trail during the summer.

From the MESA VERDE WISH YOU WERE HERE® PRINT BOOK

SIERRA PRESS: Visit us at www.nationalparksusa.com

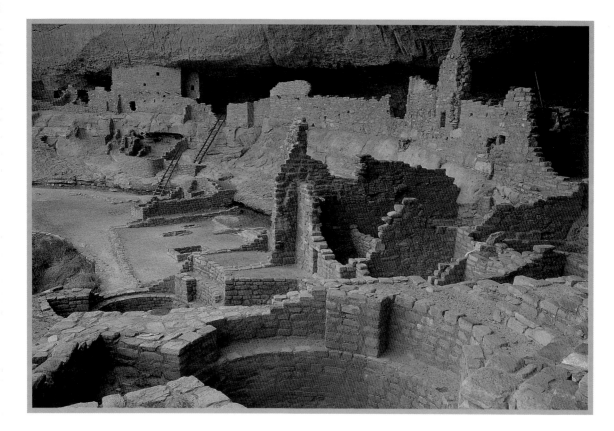

Long House, Mesa Verde National Park. Long House, located on Wetherill Mesa, is representative of the changes in archeology over the last 100 years. Long House was excavated during the Wetherill Mesa Project in the 1950s. Walls in the village have been stabilized but not reconstructed. Extensive rebuilding was common in dwellings excavated earlier in the century.

From the MESA VERDE WISH YOU WERE HERE PRINT BOOK

SIERRA PRESS: Visit us at www.nationalparksusa.com

PHOTO © STEVE MOHLENKAMP

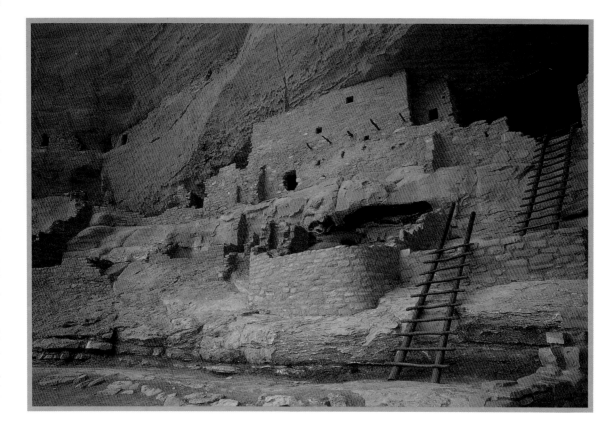

Long House, Mesa Verde National Park. The unique feature of Long House, on Wetherill Mesa, is the large central plaza. Generally considered a ceremonial or dance plaza, it may have been used for both religious and secular activities of the Ancestral Puebloan people. The small rooms directly above the village were probably used for food storage; their location may have kept rodents and other small animals from stealing food.

From the MESA VERDE WISH YOU WERE HERE® PRINT BOOK

SIERRA PRESS: Visit us at www.nationalparksusa.com

PHOTO © JIM WILSON

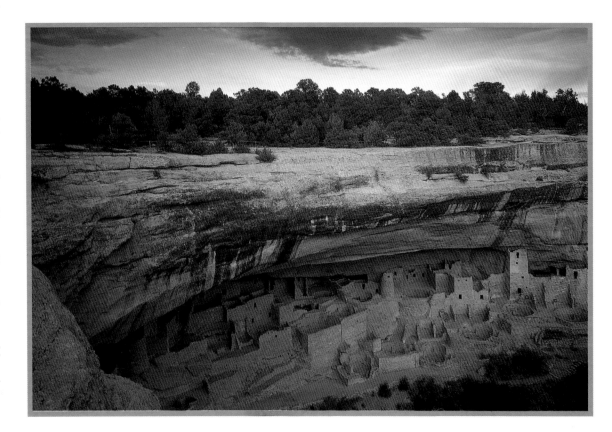

Cliff Palace, Mesa Verde National Park. Cliff Palace, the largest cliff dwelling in North America and best known cliff dwelling of Mesa Verde National Park, is but one of the more than 600 cliff dwellings in the park. Cliff Palace was likely home to more than 150 people during the height of its occupation. The Pueblo people resided in Cliff Palace until about 1275 when they left the area and migrated south and west.

From the MESA VERDE WISH YOU WERE HERE PRINT BOOK

SIERRA PRESS: Visit us at www.nationalparksusa.com

PHOTO © DENNIS FLAHERTY

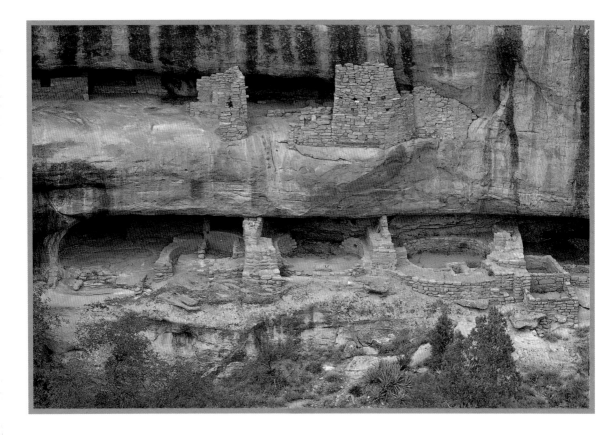

New Fire House, Mesa Verde National Park. The view from across Fewkes Canyon into New Fire House clearly illustrates some of the precarious locations for cliff dwellings chosen by the Ancestral Puebloans. A ladder was used as well as a hand and toe hold trail up the canyon wall to enter the dwelling. The walls of nearby Fire Temple contain painted men, plants, animals, and geometric designs similar to those found in contemporary Hopi designs.

From the MESA VERDE WISH YOU WERE HERE... PRINT BOOK

SIERRA PRESS: Visit us at www.nationalparksusa.com

PHOTO © LAURENCE PARENT